Dust
in the Sunlight

Gary Blakeman

ISBN 978-1-64468-940-0 (Paperback)
ISBN 978-1-64468-941-7 (Digital)

Copyright © 2020 Gary Blakeman
All rights reserved
First Edition

All rights reserved. No part of this publication may be reproduced, distributed, or transmitted in any form or by any means, including photocopying, recording, or other electronic or mechanical methods without the prior written permission of the publisher. For permission requests, solicit the publisher via the address below.

Covenant Books, Inc.
11661 Hwy 707
Murrells Inlet, SC 29576
www.covenantbooks.com

Contents

Chosen ..5
Unchanged: The Holy One ...6
Eden Restored ...9
Sunday Religion ...11
Blink ...12
God's Grace ...13
My Joy Is Complete ..14
The Author of Love ..17
The Vine ..18
The Whispering Wind ...19
The Yoke of Christ ..21
What Do You Require ...22
Christmas ..25
Down from My Cross ...26
Thanksgiving ...27
I've Only Begun ...29
New Year's Prayer ..30
Forks in the Road ..33
A Mother's Love ..35
Doubt ...36
Ephesians 3:18–19 ...39
From the Heart ..41
Heaven Is… ...43
Why Darkness? ..45
Intercessory Prayer ..47
2005 Prayer ..49
2006 ...51
Spiritual Chain Letters ...53
What If Only Darkness ...54
Beauty Overcame Darkness ..57
Grace ..59
Dust in the Sunlight ..61
My Existence ...63
Mirror ...65
Worship ..67
Serving God ..69
God's Temple ..71
Every Day ...73
Draw Close ...75

Fathers	77
Ripples of Love	79
Eternity	80
Christmas '08	83
His Tapestry	85
A Christmas Miracle	86
Good News	87
Dependence Day	89
Draw Me Closer	91
Forgiveness	92
Mountains and Valleys	93
Easter 2011	95
Easter	97
This Year and Next Year	98
True Christmas	99
Jesus Shoes	101
God of Wonder	103
Relax	104
Today	105
Always Today	107
Born to Die	109
God Is One	110
Your Christmas Miracle	111
Hope	113
You Gave Me Today	115
God's Valentine to Mankind	116

Chosen

I have chosen to follow Jesus
Because He first chose me
I have chosen to follow Jesus
He made my eyes to see

See the glory of His death
His death up on the cross
See that losing my sinful habits
Would really be no loss

Thank You, Jesus, for Your gift
Your gift of love that day
That day You died on the cross for me
Forever I will say

I have chosen to follow Jesus
Because He first chose me
I have chosen to follow Jesus
He made my eyes to see

See the love of God the Father
See the risen Christ on high
Feel the power of His Spirit
A power you can't deny

All praises to my Jesus
For the sight I have received
The sight He has given me
Since the day I first believed

I have chosen to follow Jesus
Because He first chose me
I have chosen to follow Jesus
He made my eyes to see

Unchanged: The Holy One

There are times when I am down
Times I feel You're not around
When I feel like You aren't there
And I wonder if You really care

Then I take refuge in Your word
Unchanged since I first heard
And I know You'll never leave
Then Your comfort I receive

You never change, You are the same
As You were from the beginning
You are the Holy One!
You are the Holy One!

There are times when I'm elated
So glad I've been created
When I feel like You're so near
Like You've always been right here

Then I rejoice in Your word
Unchanged since I first heard
And I know You'll never leave
Then your comfort I receive

You never change, You are the same
As You were from the beginning
You are the Holy One!
You are the Holy One!

My feelings may change from day to day
I know they can only lead me astray
But Your word ever remains the same
All glory to Your Holy Name!

And so I revel in Your word
Unchanged since I first heard
And I know You'll never leave
Then Your comfort I receive

You never change, You are the same
As You were from the beginning
You are the Holy One!
You are the Holy One!

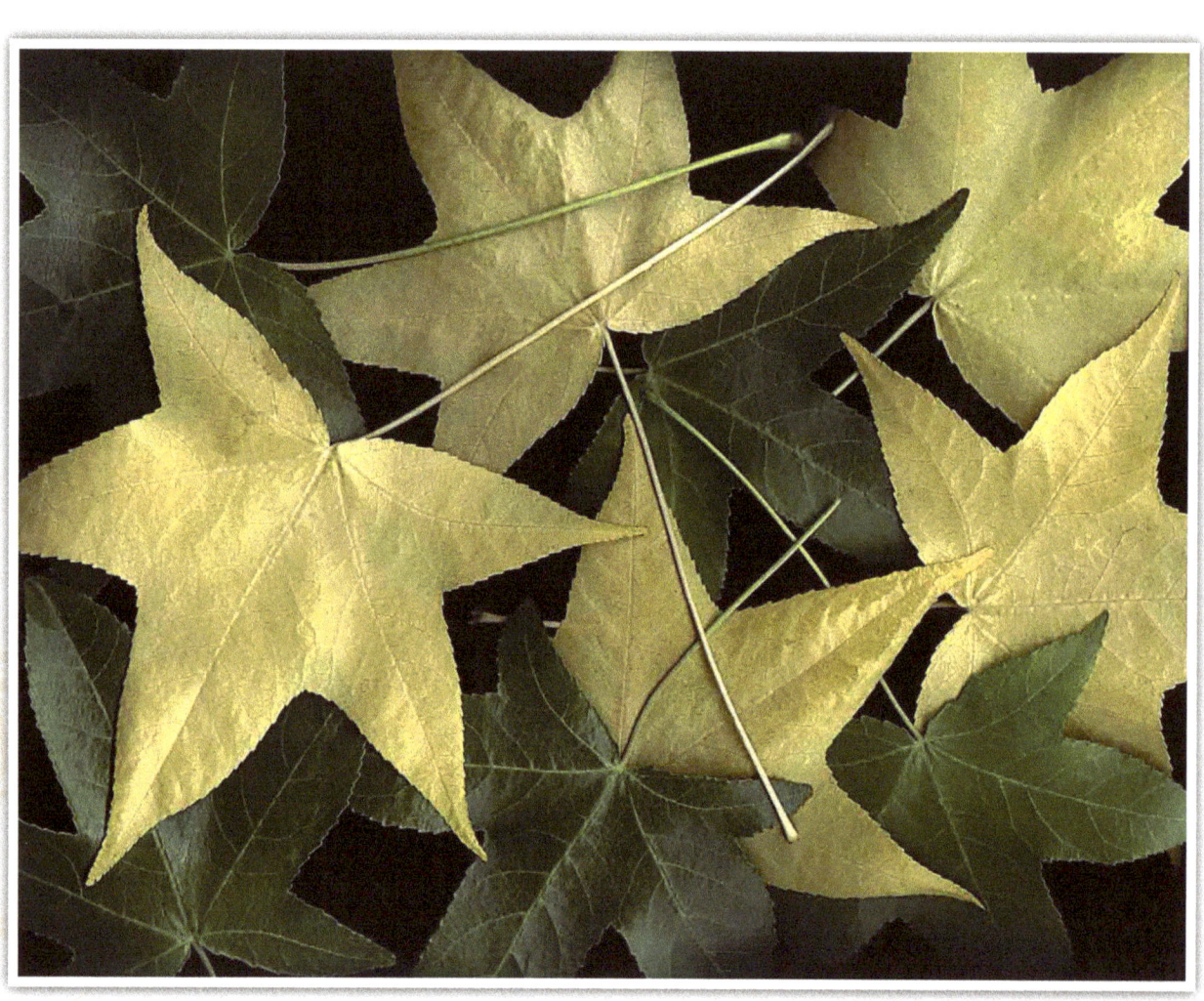

Eden Restored

The time is coming when time will end
The time when to heaven all saints ascend
The time when time will be no more
The time all saints have been praying for

That is when time will be abolished
When all our halos will be polished
When those asleep in Christ will lead
And those alive in Christ proceed

The time when time will lose all meaning
When eternal peace we'll be receiving
When eternity will replace time for good
Just as God has promised it would

Be patient all ye saints that wait
Be assured that the hour grows late
The time of our Lord's return
The time for which we all yearn

The time we've waited for from the first
The time for which each of us does thirst
Thirst for the coming of our Lord
When we will receive our promised reward

Eternity is what we seek
With the One who is unique
Forever more with our Lord
Forever more in Eden restored

Sunday Religion

I love the Sunday service
It's a time I feel close to You
I love to hear Your Word
And I love the singing too

The Sunday service is a time
For worship and for praise
But why is there emptiness
When I miss the other days

I want to serve You every day
I want to be more like You, Lord
But this would be impossible
If the other six I ignored

I want more than Sunday religion
More than one day a week
I need more time to grow with You
More time Your will to seek

Commune with me every day
Lord, renew my spirit inside
Draw me close, draw me near
With You, I need to abide

There are seven days in a week
I need a daily walk with You
One day a week is not enough
To keep my faith renewed

Each day I hunger for Your Word
Draw me daily to You, Lord
I need all seven days
To keep my spirit restored

I want more than Sunday religion
More than one day a week
I need more time to grow with You
More time Your will to seek

Blink

Just how long does it take to wink
For you to make your eye to blink
Only an instant, only a second
Is what it takes to blink I reckon

From one's birth until life's end
Tell me what you think my friend
When compared to God's forever
What's the total of your life's endeavor

It's no more than the blink of an eye
A very small piece of a very large pie
Ponder eternity with God and then
Ponder the time on earth you spend

And when you consider eternity
Contemplate this and you might agree
Time spent here is but a nod
Next to eternity spent with God

Spend this short time wisely then
So when you stand before God and men
When you stand in the light of the Son
At the judgment when your life is done

God will smile and He will say
It's good to have you here this day
Your mansion has been prepared for you
Eternity you'll spend with Me, it's true!

God's Grace

If you could see God's grace
If your sight, He would permit
If you could touch God's grace
What would be the feel of it

It would be the face so wrinkled
By so many years spent here
If you could see God's grace
This is how it would appear

I think the beauty of His grace
Would outshine all the suns
That ever have been created
Since the day creation begun

The feel of God's grace
That you long for very much
Would feel like softest velvet
If His grace you could touch

If God's grace you could caress
With your hand or with your cheek
It would no doubt feel to you
So soft and so unique

If you want to see God's grace
Look with the eyes of your soul
And feel grace in your heart
All your troubles to console

Then allow your heart and mind
To accept His gracious love
In the form of His Son Jesus
He's as gentle as a dove

My Joy Is Complete

Lord, in You my joy is complete
You have saved my soul from pit
I bask in the light of your glorious love
And to you my life I will commit

Now my name is in the Book of Life
Great joy have I received
Because You have chosen me, my Lord
Your praises I will eternally sing

My joy is complete, I'll never need more
You have written my name in the Book
My joy is complete, I'll never need more
You have written my name in the Book

Lord, I eagerly await your return
When I will see You in all Your glory
Until You come to take me home
I will sing to the world this story

Now my name is in the Book of Life
Great joy have I received
Because You have chosen me, my Lord
Your praises I will eternally sing

My joy is complete, I'll never need more
You have written my name in the Book
My joy is complete, I'll never need more
You have written my name in the Book

When I stand in Your presence
On that final judgment day
My joy will truly be complete
Then I will rejoice and say

Now my name is in the Book of Life
Great joy have I received
Because You have chosen me, my Lord
Your praises I will eternally sing

My joy is complete, I'll never need more
You have written my name in the Book
My joy is complete, I'll never need more
You have written my name in the Book

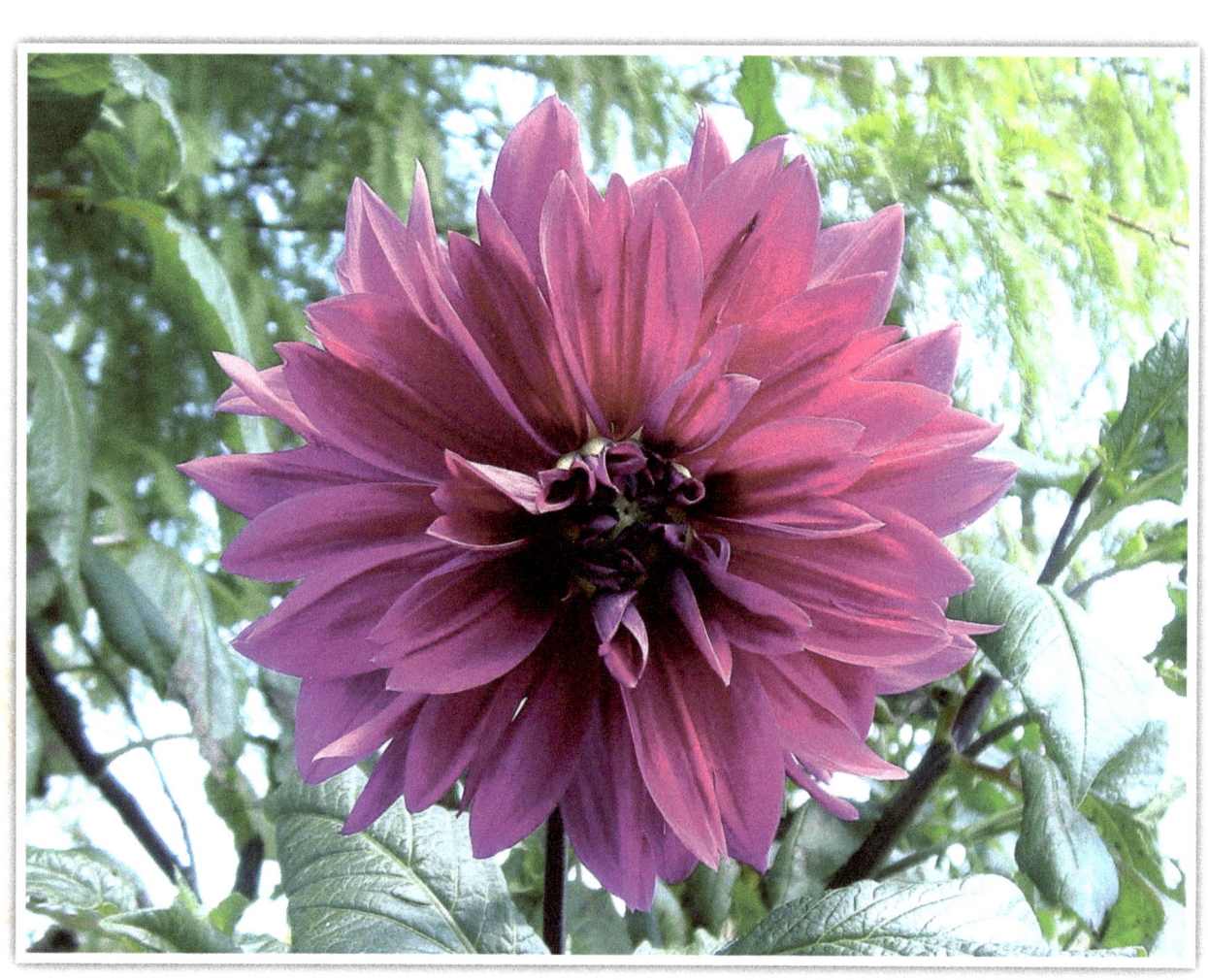

The Author of Love

Because of my love, which You always pursued
Because of this life that You've given me new
The joy I have now makes my heart sing
And I know with You I can do anything

This love of Yours has given me power
It grows within me each and every hour
That I spend with You, the Author of Love
As peace comes to me on the wings of a dove

Because of this love that You've given me
My life has changed forever you see
Then why so long, oh this heart of mine
Did you wait to accept this love so divine

Ah, that is a matter of the distant past
Something You always knew could not last
For this You have known from the beginning
That my soul some day You'd be winning

So through this life we will walk together
No matter how fair or stormy the weather
My head will always be held up high
Because on Your love I will always rely

When Your love reaches out to me every day
When Your love reaches out to me every way
Then my heart answers back to You and Your call
My heart answers back to You with its all

I sing this song to the Author of Love
I will sing this song forever in love
With the One who loves me with a love underserved
Your love, my Lord, will I faithfully serve

The Vine

You made us branches of the true Vine of Life

When we walked in a world where there was no light

When there was no deserving of Your love, Your grace

By us who once lived in this world's rat race

You are the Vine and Your Father, the Vinedresser

You have saved us from this world's oppressor

And made us branches in you on the Vine

You lifted us up and made us to shine

That we glorify the Father by bearing fruit

Now that you've given us a clean new suit

Different from that which we once wore

In the worldly life we lived before

We will bear more fruit since You cleansed our soul

You gave us a more noble and righteous goal

When we abide in You, we will clearly see

That we will bear much fruit and be truly free

And will bring glory to the Father above

Which is why He created us out of His love

The Whispering Wind

Can you hear the whispering wind?
Can you listen without saying a word?
The wind requires your ear today
Is what it says really so absurd?

You've heard it so many times before
Don't turn your ear away
Not this time, my friend, my friend
This is your moment this is your day

Consider the breeze that tickles your ear
With words of wisdom, listen
And to you they will appear
As jewels in the mist that glisten

Can you hear the whispering wind?
Can you listen without saying a word?
The wind requires your ear today
Is what it says really so absurd?

This whispering wind you hear
Has blown since time began
Long before there were ears to hear
Long before God created man

The wind quietly whispers to you
From Christ, I bring you salvation
I am the Holy Spirit of God
Whispering since before God's creation

Can you hear the whispering wind?
Can you listen without saying a word?
The wind requires your ear today
What it says is not so absurd

The Yoke of Christ

You looked at Me and then You spoke
Come walk with Me, You said
Come walk with Me, take on My yoke
I'll ease your worried head

For My yoke is easy, My burden light
I'll always be here by your side
The road with Me is always bright
I'm here with you as your guide

During our journey through this life
The road will not always be smooth
There will be troubles and strife
But I'm here your pain to soothe

Cast all your cares on Me each day
And keep your eyes on the goal
From My Word, do not stray
For My Word is balm to your soul

Take on the yoke of suffering with Me
I'll always be here with you
Keep the faith and you will see
Each day, your strength I'll renew

Pain and suffering can't be compared
To the wonders I have waiting for you
For your mansion is now being prepared
Believe what I say is true

What Do You Require

I asked the Lord what He required
And He said for the rest of your days
To fear the Lord thy God
And to walk in all of His ways

For all the days of your life
This should be your goal
To serve the Lord thy God
With all thy heart and soul

What would You require of me?
Tell me, Lord, tell me now
What would You desire of me?
To obey You is my vow

Keep the commandments of the Lord
And the statutes I command you this day
Blessings will surely come to you
When My commandments You obey

For all the heaven above is God's
And the heaven of heavens is His
The earth too belongs to Him
And all therein that is

What would You require of me?
Tell me, Lord, tell me now
What would You desire of me?
To obey You is my vow

For all the days of all my life
This will be my aim
To keep all Your commandments
And to glorify Your name

For You are an awesome God
You are just and true
And merciful and loving
All praises be to You

What would You require of me?
Tell me, Lord, tell me now
What would You desire of me?
To obey You is my vow

Christmas

C is for the Christ child
Swaddled in a manger
H is for His holiness
To which He is no stranger
R is for the resurrection
Of the Chosen One
I is for intercession
For us by God's only Son
S is for our Savior
In all His glory and power
T is for our trust in Him
Each and every hour
M is for the Master
Hallowed be His name
A is for the angels
His glory they proclaim
S is for His saints
Who worship Him in spirit
Awaiting His return
His kingdom to inherit

Down from My Cross

Joseph (of Arimathea)

You took Me down from My cross

Wrapped Me in a linen cloth

Using myrrh and aloe spice

Not taking notice of the price

So had the prophet Isaiah spoke

Of your boldness what now awoke

To place Me in your private tomb

In grief on this dark day of gloom

While days gone by you hid your faith

Perchance to cover up this wraith

That lingers dark behind the scenes

Your faith and love caught in between

The fear of those who know you well

And Me, the friend you bid farewell

At last your naked faith unfolds

Just as the prophet erstwhile told

Your love laid bare for the One

Who is God's one and only Son

Thanksgiving

Every day is Thanksgiving
That I spend with You
Every day is Thanksgiving
Because of what You do
What you've done for me God
And for all mankind besides
You gave Your only Son
So that we could take long strides
Toward Your perfect being
To become more and more like You
With the Holy Spirit's help
Each day we try anew
It's easy to find reasons
To be thankful for You, Lord
We only have to open our eyes
Your faithfulness can't be ignored
Your love has no bounds
For that I thank You too
Your grace is unending
It always sees me through
Every day is Thanksgiving
That I spend with You
Every day is Thanksgiving
Because of what You do

I've Only Begun

I've only begun to praise You, Lord
This love of Yours just can't be ignored
I've only begun to give thanks to Thee
For the unending love You have for me

This faith I received as a gift from You
All of this life will carry me through
Faith will serve me 'til Your return
In eternity, it will be of no concern

Just as the hope of salvation You give
While on this earth for it I will live
After that time, there will be no need
For then on Your love ere will I feed

Faith, hope, and love now endure
Right up 'til that day when my soul is secure
Secure in eternity when all there will be
Is my love and praise only for Thee

The day will come when to my King
For all eternity I will sing
Praises to You, my faithful Lord
With all the saints in one accord

I've only begun to praise You, Lord
This love of Yours just can't be ignored
I've only begun to give thanks to Thee
For the undying love You have for me

New Year's Prayer

Father, this last year has had some dark days
Famine and war and decay of man's ways
Earthquakes are rumbling all over the earth
People are living like life has no worth

The poor getting poorer, the rich getting richer
Sin poured out like water from a pitcher
But those who read Your Word know the score
You said this would happen and so much more

You said these things would all come to pass
Evil will flourish in the end times, alas
But I thank You, my Lord, the great I Am
That our hope lies in the blood of the Lamb

Lord, hear my prayer for this coming year
I ask that You help all Your saints persevere
Persevere in our faith in Your living Word
Let not our eyes by this world be blurred

Help us to grow spiritually healthy and strong
Abiding in Your Word abstaining from wrong
Bringing You honor and bringing You glory
Telling the world of Your wonderful story

Make us Your tools to bring hope to mankind
Spiritual hope to the spiritually blind
We thank You, God, that our hearts You pursue
We give You the glory for it belongs to You

Forks in the Road

There are many forks in the road of life
Which we travel each and every day
Each fork is a choice that we must make
Seek God's help so as not to stray

Each time you come to a fork
Don't be hasty in the direction you choose
Weigh your decision carefully
So you won't be singin' the blues

These forks are tests for us you see
God allows them for a good reason
We may not understand them now
But we will in good season

These tests are for our growth
To become more like our Lord
They may be sometimes painful
But in time, we'll receive the reward

You won't always make the right choice
So don't be discouraged when you fail
Get back up and dust yourself off
Your faith, in the end, will prevail

Pass or fail at each of these forks
Praise God for the results of the test
For this is what He expects from us
And for this, we will be blessed

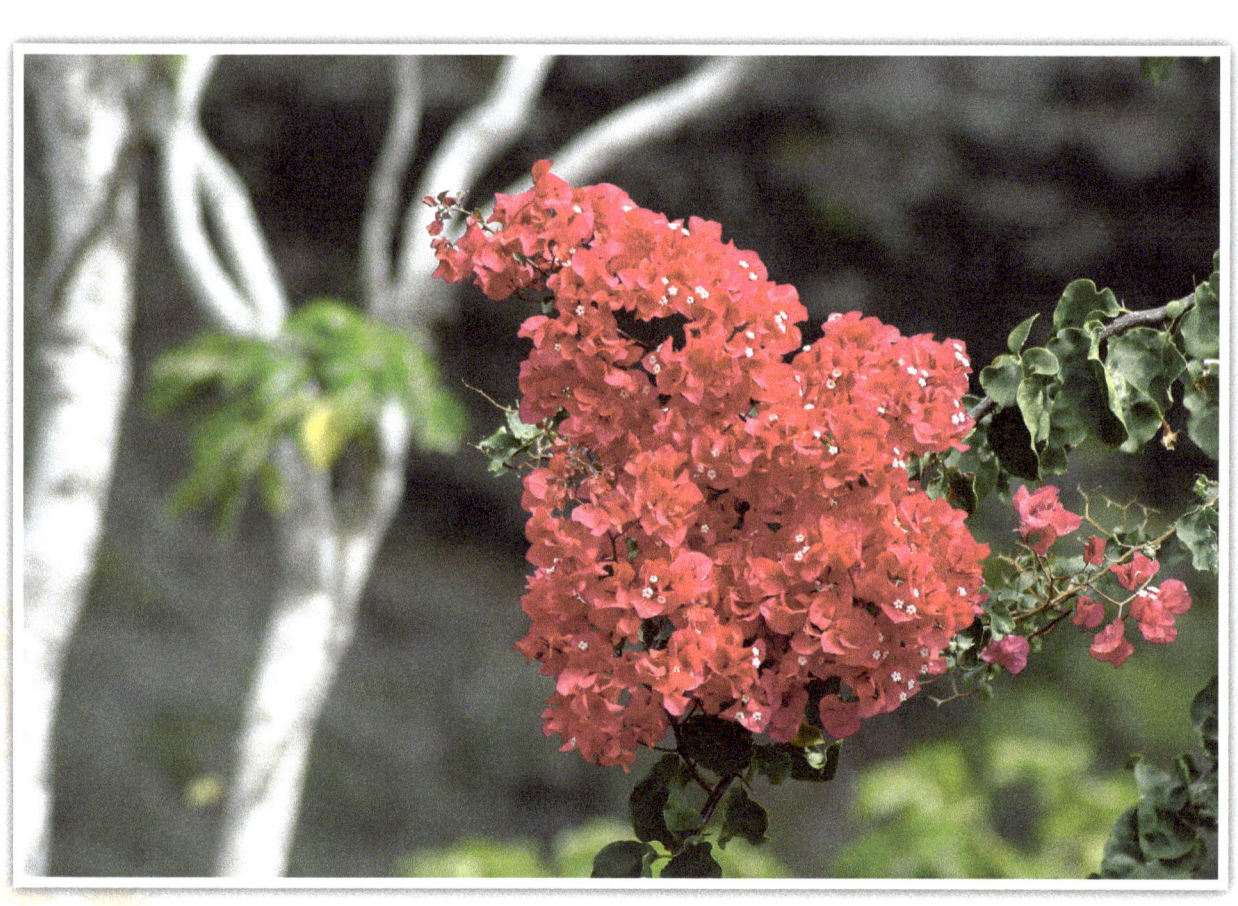

A Mother's Love

Have you read 1 Corinthians 13 lately?
The chapter written about love
I think Paul had mothers in mind
Telling us just what they are made of

This love God is trying to teach us
Has been around since time began
He places it in all mother's hearts
Who love us like no other can

Only the love of a mother
Has all, I would like to suggest
Needed to nurture a baby
As she cradles him close to her breast

A mother puts her children first
Wants only for them what's best
Is sad when they are downhearted
And calms them with her sweet caress

Mothers never give up on their own
Never lose faith in them
They love us no matter what
Each child in their eyes a gem

So this year remember your mother
Whether she is with you or not
And thank God for her undying love
That's been with you since you were a tot

Doubt

When doubt in my mind starts creeping
Keeping me from sleeping
Sweeping, sweeping my reasoning away
There is no worse torture to my soul
Feeling out of control, no one to console me
Not knowing where to turn, I yearn
For direction, for relief
From this wretched monster, doubt
It stalks my very soul
How will I cope, where is my hope?
Where is the soap to wash this doubt away?

Only one place to look, in the Book
The one that first took doubt from me
In its light, how will I view this doubt, this drought
Lord, on me pour your Spirit out
You alone have allowed this question
Depression, oppression, regression
For only one reason, just for a season
My faith and loyalty to test

Now I know that I am blessed
I know I will endure this test
Along with all the rest
That come my way, This I pray
That I won't betray, my faith,
Precious gift from You

Extravagant: adj.

1. Given to lavish or imprudent expenditure
2. Exceeding reasonable bounds
3. Extremely abundant; profuse
4. Straying beyond limits or bounds

Ephesians 3:18–19

Your love is extravagant
Your love is so wide
Your love is extravagant
This can't be denied

Your love is extravagant
Your love is so long
Your love is extravagant
Your love is a song

Your love is extravagant
Your love is so high
Your love is extravagant
Your love makes me sigh

Your love is extravagant
Your love is so deep
Your love is extravagant
I joyously weep

Your love is so great
There is no doubt
It's hard to understand
I can't figure it out

But I thank You, I praise You
My Lord, for Your love
That You pour out on us all
From heaven above

From the Heart

When you come before the Holiest God
With prayers upon your lips
When you voice those words of praise
Are they recited like movie scripts

Are your prayers and praise mechanical
Are they merely "lip service" to God
Does your prayer life appear to Him
To be only a transparent facade

And when before God's throne of grace
You come to place upon the altar
Those prayers and praise for Him to hear
Is your heart like the rock of Gibraltar

Before you utter a single sound
For the Holiest of Holies to hear
Examine your motives and your heart
And then with confidence draw near

To the One who sees and knows all
Let your supplications be honest and pure
When you pray to God "from the heart"
He will hear you, of this be sure

For God looks deep into the heart
Of those who enter into His light
He knows your needs and desires
To answer them is His delight

Even before you offer your prayers
God knows what you will say
And He's at work to answer you
With a prayer-answering bouquet

So when you offer prayers and praise
To you this advice I impart
Let them not be lip service
But speak with verity from the heart

Heaven Is...

Heaven is like a rose created by God
Starting as a bud no more than a pod

Unfolding, it opens ever so slowly
Revealing its beauty eternally holy

This eternal rose never fully opening up
But ever remains as a bottomless cup

For all Saints, the elect of the Lord
Never more thirsty drinking in his Word

Heaven ever changing just as the rose
Eternally beautiful to each He chose

For all of eternity unfolding like that rose
Heaven ever changing as its beauty grows

Why Darkness?

In all of our troubles, illness, and strife
In all that seems so terrible in life
God is aware of all we go through
He sees each and everything we do

Contemplate this when things look so dark
When life has seems to have lost its spark
His Spirit is there standing by you
He promises this, I know it is true

What is His reason for allowing this pain
We feel in our lives when it comes down like rain
Each case is different and each is unique
In each of our lives when all looks so bleak

God has good reason, we must never doubt
Turn to Him and pour your heart out
Ask Him to open your eyes to His reason
For allowing this pain in your life for a season

He promises this in the Book of His Word
That our cries of sorrow won't go unheard
The ultimate reason for all we undergo?
Opportunity for His love on us to bestow

To teach us to depend on Him maybe more?
To draw closer to Him than ever before?
The reasons are unlimited, infinite in scope
All are for strengthening our love, faith, and hope

Intercessory Prayer

Our intercessory prayers are sweet incense
To our Creator and Savior, God
He's at work to answer them as we speak
We should not at all think it odd

For our Lord loves that we show concern
When offering prayers to intercede
It's not important that they know who we are
Only that God knows our cares when we plead

Know that God's answer to our prayers
Will now always be as we would have it
But know He loves those whom we lift up
So our intercessory prayers should never quit

Be consistent in prayer day in and day out
Let you cares for each other be known
To a God whose love we can't fully understand
To a God who reigns sovereign from His throne

The Holy Spirit intercedes with groanings
Which cannot be expressed
When we know not what to pray
For that we are most blessed

So follow the Spirit's leading
And continue to offer to our Lord
Prayers of intercession for each other
Which we know will not be ignored

2005 Prayer

Here's a New Year's prayer for everyone
That will glorify God every day
I pray all that read this poem
Will heed each word I say

It's good to celebrate our Lord's birth
Every year on the 25th of December
After all, they did it 2,000 years ago
With gold, frankincense, and myrrh

What if we celebrated Christ's birth,
Life, death, and resurrection too
Not only once or twice a year
But daily with a zest that's true

And what if the gifts we gave
Every day were gifts of just US
Which is the example set by our Lord
When He gave His life for you on the cross

Lord, this is my prayer for us all
Each and every day this year
That You would motivate us
To love, live, and give with cheer

Help us to develop those traits
Which exemplify You, our Lord
That we may bring You much glory
A glory that can't be ignored

2006

I've written poems before, for the New Year we look toward
For encouragement, edification, and for the glory of our Lord

As this year draws to a close and the new looms on the horizon
We look back at what we've lost and also what we've won

Some have lost loved ones, some have lost their health
I weep with those who weep, yet we must look at our wealth

What wealth is this you say when our losses are so dear
Our wealth lies in Christ our Lord who is ever so near

In our times of tribulation, in times so dark and cold
The blessed Holy Spirit's love within us doth unfold

Because of His love so true, ever present in our lives
We look forward to the New Year, knowing we will survive

In Him we have the victory over the grave and over death
As told to us in 1 Corinthians verses 15:51, 2, 3 and 4th

The year 2006 will bring us trials and victories too
For to weep with those who weep and for to rejoice in the truth

This coming year, open up your mind and open up your heart
So to you God's eternal love, the Holy Spirit may impart

Thank you in advance, my Lord, for what this year will bring
Knowing You are still in control of each and every thing

Spiritual Chain Letters

I hope you know I love the Lord
And I love you too, dear friend
I know your intentions are really good
When those "spiritual chain letters" you send

They say to mail it to ten more people
And back to me if you really care
And then I'll receive a miracle from God
In four days and that I swear

Fifty-some years ago you see
A miracle already happened for me
I asked Christ's forgiveness for my sins
He gave me eternal life for free

I experience His blessings every day
For I live my life for Him only
Because He loved me enough to die
I will never again be lonely

So please don't think the less of me
Because I don't participate
In e-mailing "spiritual chain letters"
But I still think you are great!

What If Only Darkness

What if in the morning
When you opened up your eyes
You saw only darkness
Not the sun to fill the skies

What if only darkness
Was what you saw all around
No matter how far you looked
Only darkness did abound

What if only darkness
All the days of your life
What if every step you took
Was filled with naught but strife

What if all the Bible said
Turned out to be a lie
What if the Christ you've heard about
Is not the God on High

What if 2,000 years ago
When Christ was put to death
What if darkness reigned
And He never breathed another breath

What if there were no light
To guide you down the path
What if only darkness
Well, you do the math

This must have been what Christ's followers
felt immediately after His crucifixion

This is what all Christ followers have felt
ever since His resurrection

Beauty Overcame Darkness

Today Beauty overcame the darkness
Let the heavens hear your cry
Hallelujah! Christ has risen!
Raise your voices to the sky

Hallelujah, praise the Lord
Christ has risen from the tomb
God brought Him back again
The aroma, sweet perfume

All glory be to the God
Who brought Him back again
It's a time of celebration
Break out the best champagne

Sing songs of adoration
To the risen Christ, our Lord
Let our voices join together
To sing in one accord

All praises to our King
Born to die upon the cross
This world and all our gains
For His sake we count as loss

Today Beauty overcame the darkness
Let the heavens hear your cry
Hallelujah! Christ has risen!
Raise your voices to the sky

Grace

What is this "grace" we've heard about
Ever since we've had ears to hear
That thing that we believers
Have always held so dear

Grace is mentioned in the Bible
Over one hundred and eighty times
It's talked about in sermons
And it's written about in rhymes

I've heard it said many ways
Over the months and the years
And when I stop and think
Grace always brings me to tears

Grace is marvelous, it's wonderful!
Without it, we'd have no hope
It helps us through our troubles
Each day, it helps us cope

It's not easy to define grace
In a way that's clear and true
But see if this makes sense
When I spell it out for you

How do I spell grace?
God's unwarranted gift to us
How do I spell grace?
It's J-E-S-U-S

Dust in the Sunlight

When I look at all You have created, LORD
At the vastness of the universe
And then look at myself
I am but as dust in comparison
Like a small speck of dust in the sunlight
How tiny and insignificant I appear against it all
It amazes me that You can see me
Yet You do
This tiny speck of dust
Floating around among the billions
And billions of stars
And You know exactly where I am
In the midst of it all
You know my every thought
My every need and desire
And graciously You provide for them
Every day, every breath, every heart beat
You are so glorious, God!
So loving and wise
Thank You for Your grace and mercy
And patience with one such as I
Mere "dust in the sunlight"

My Existence

There are only two reasons
For my existence here on earth
I consider all other matters
To be effectively of no worth

The first is to avail myself to God
For his glory to shine through
Each and every day I live
In each and every thing I do

The second is for you, my friend
To help open up your eyes
To all He has to offer you
I would never tell you lies

For lies are what you hear each day
From the news and from TV
There is only one truth and one God
Study His Word and you will see

This is the only truth you need
Christ died for you, my friend
For to set you free from all your sins
Repent and on His salvation depend

Don't try to change yourself at all
You've not been given that task
Christ is waiting for you to turn to Him
For His forgiveness, you only need ask

Mirror

I am not the source, only a mirror
So draw me to You nearer and nearer
So when all the world looks at me
The only thing that they will see

Is Your light in me shining brightly
Reflecting your love, daily, nightly
Showing those whose eyes can see
How You're e'er waiting to set them free

Lord, make me a mirror of Your love
For this is what I e'er dream of
That when people would see my face
They would see the picture of Your grace

Change me, Jesus, through and through
Change me daily to be more like You
Cause me by Your Spirit to transform
Change me from the worldly norm

My desire is to be Your mirror clearly
For those who need You so very dearly
That they might see Your love flow
That Your great love they might know

Hear me, Lord, this my prayer
Give me courage to declare
The good news of Your holy word
To all those who have yet not heard

Then my purpose here on earth
The very reason for my birth
Will never have been clearer
When of You I am a mirror

Worship

Let all those far and near
All those who have ears to hear
Listen to what I have to say
To each and every one this day

I lift up to you one and all
My Christ who puts out His call
Worship Me and me alone
Worship Me upon My throne

Worship not your silver and gold
Shiny yes, but dead and cold
Worship not those things you see
Come and worship only Me

For I alone can bring you life
Free you from your toil and strife
Soothe you, calm you, and bring you peace
Cause your worries and cares to cease

Worship and praise Me through your woes
For I am the One whom the Father chose
To free you from those chains of sin
To bring you back to Him again

Back to worship in spirit and truth
The One you've heard of from your youth
For I alone can heal your soul
I alone can make you whole

Serving God

It is God Who serves us
In every single way
In all we have and do
Each and every single day

What can we give to God
Who has made all that there is
In fact if you think about it
All that exists is really His

In light of what I said
What then are we to do
Since we thought we served God
But now we know that it's not true

Listen closely to what I say
Each and every one out there
Avail yourself for God to use
That is, do it if you dare

For once you give yourself to God
To use as He sees fit
It means giving up your will
And to him your life submit

He'll use you for such marvelous works
To serve all His creatures here
Works beyond your wildest dreams
When to His word you adhere

Working hand in hand with Him
I think that you will find
You're no longer His servant
But an heir with Christ entwined

God's Temple

God is building a temple for all to see
He is building a temple with you and with me
A brick at a time, each firmly in place
He's building a temple with the human race

The elect of Jesus are the bricks God uses
Building around the clock, all the bricks He fuses
Fused together, the bricks called the "Church"
Each day for bricks the Holy Spirit does search

The bricks are fired in a furnace with care
For a grand temple, His glory to declare
None but the best will be used by the Builder
While the hard of heart stand perplexed and bewildered

God lives in His temple as it's being built
Soul by soul…it won't lean, it won't tilt
Sturdy and strong this temple will stand
From the beginning, just as He planned

So let Christ soften your heart if you will
For He gives the Holy Spirit, your heart to fill
When He comes looking to use you as a brick
Let your answer to Him be sure and be quick

When the temple's complete and Christ comes again
For those called His saints, the women and men
In this temple God will live for eternity e're
His love and His holiness with us to share

Every Day

Christmas celebrations wind down
And the New Year is coming
The winds are ablowing
And the cold is so numbing

But thanks be to our God
Who warms us so much
By the heat of His Spirit
When our soul He does touch

So join me in celebrating
Christ's birth every day
In all that we do
And in all that we say

Celebrate the days of His life
Along with His death
And how the Father raised Him
With a word of His breath

Let your celebrating continue
Each day of your lives
All of you children
And you husbands and wives

So that the world will see
His love for us so dear
Is not just for a season
But every day of the year

Draw Close

We all need healing, one time or another
Be it physical, spiritual, or mental
We all need God's healing touch
Times we all need His touch so gentle

Have you ever wondered just why
Why God has allowed that "need"
When He could have just stopped it
And never allowed it to proceed

We all know that God has the power
To do whatever He will
To let time go on for ever
Or to stop it and make it stand still

Could it be He's trying to get our attention
So to bring us to that place
So we will draw close to Him
And experience His love and grace

The reasons are as many
As there are grains of sand I guess
That God allows these "needs"
So in the end our souls He can bless

When in those times of need
The eighth verse of James 4 is so true
Draw close to God, my friend
And He will draw close to you

Fathers

Fathers, we have a perfect picture
Of what it means to be
The father of a son or daughter
With this you must agree

This is a picture of God the Father
And how He relates to Christ His Son
Is this not the perfect picture
For fathers, each and every one

Their love for each other
Is perfect and complete
All throughout eternity
Their relationship, replete

Dads, keep looking at this example
Given to us by our Lord divine
How to raise your children
So His glory in them will shine

Raise them how they should go
So that when they grow old
They won't depart from the ways
That lead to the streets of gold

Our unconditional love for them
Must always be ample
So when they raise their children
They have our love as an example

Ripples of Love

Those deeds of ours, both good and bad
Which make others feel great or sad
Don't cease to exist at the end of the day
Yes, all those things we do and say

All our works and the help we give
Last well beyond this day we live
Just like a rock thrown in a pond
The ripples continue far beyond

So be sure to live the life you should
Following Christ and doing good
When each day you rise at dawn
Remember those ripples go on and on

Those ripples of love that you sow
Go much further than you know
Bringing glory to our gracious Lord
And this by Him won't be ignored

Remember Christ in all His grace
Has revealed to us the Father's face
Showering us from heaven above
With waves of His unending love

These waves of love like a flood
Started from Christ's own precious blood
And so to Him, mankind is drawn
By ripples of love that go on and on

Eternity

From the moment you we were born
Of a woman to this world
Not just by chance alone
Were you onto this earth hurled

Think on this, you who belong
To the Creator of all that is
I have some questions for you
Sharpen your mind for this quiz

Were you known to God above
Before you first ever were
Way back when creation
Was nothing but a blur?

Did He know from the beginning
Just who and where you'd be
Before the earth was formed
And there was nothing but the sea?

When Christ made His sacrifice
Back there on Calvary
Did He know that you'd accept
Eternal life for free?

Before your life began
Before you first would cry
Did not the Lord above
Know that you would never die?

From the moment you were born
Will you not agree with me
Was when you first started
A life with God in eternity?

When death is swallowed in victory
And your earthly body changed
Will you not be just like Christ
Yes, eternally rearranged?

So when all is said and done
At the end of the day
I have one more question
To this what will you say?

Why not start singing halleluiahs
To the glorious Lord above
Now and through eternity
Out of gratitude and love?

Christmas '08

Many poems are written and many stories are told
As we watch the miracle of Christmas unfold
While visions of sugarplums dance in kid's heads
Grandma's in the kitchen baking fresh bread

The crackling fire brings warmth to our faces
A time for loved one's warm embraces
Nostalgia of bygone days unwind
Childhood memories linger in our minds

Some 2,000 years ago on that marvelous day
When Christ was born many miles away
He made it possible for us to enjoy
All these things, yes, every girl and boy

Because of Him, we live and have breath
From the day we are born till the day of our death
And those who call Him their Master and Lord
Will soon be blest with their promised reward

That reward of eternal life with Christ
Who with His precious life paid a dear price
Lord Jesus, we praise You and thank You so much
For all Your blessings and Your loving touch

His Tapestry

Behold the tapestry of God
Master Weaver from eternity
Designed before the whispers of man
Beyond understanding in its complexity

The Master's loom, eternity itself
His yarn, none other than Saints
Who wait with great expectation
As He weaves without constraint

The shuttle used to guide the yarn
Is Christ the great I Am
The Weaver's one and only Son
How worthy is the Lamb!

Our every thought and action
Anticipated before earth's dawn
And all skillfully interwoven
In beauty by the Master's hand

Though times we stagger and stumble
Missing the mark by a country mile
The Weaver, with no hesitation
Busy weaving all the while

When His tapestry is complete
With a smile He will declare
This, My crowning work of art
Without doubt is beyond compare

What form will this tapestry take
With the addition of the last thread
For all the saints of Christ
When with Him, we all break bread

His tapestry when completed
The Master's great creation
Is the very bride of Christ
The Church in celebration!

A Christmas Miracle

It all started with a miracle 2,000 years ago
Never before or since has it happened
The only virgin birth of a child
When God to earth had descended

The King of angels himself came to earth
In the form of a carpenter's son
Humbling Himself to the hand of the Father
His thirty-three year journey just begun

From the time of His birth 'til his death
Many miracles did He perform
While preaching His Gospel of life
Many lives did He transform

He looked at us and He said,
"Come all ye weary and heavy laden
Take My yoke and My burden light
Every man and every maiden"

Then in obedience He went to the cross
Made to be sin, He who knew no sin
To free us from our stony heart
And give us a heart of flesh within

Now create a Christmas miracle
For this special time of year
And give away your love to others
To fill their hearts with cheer

Good News

What is said in the four Gospels
Is good news for every ear
Anyway, that's what we're taught
In church that's what we hear

My brothers and my sisters
Do you really believe it's true
What Matthew, Mark, Luke, and John
Has been saying to me and you?

If we really do believe
What we see here in Your Word
Is an account of those before us
A true account of what's occurred

Then shouldn't we be shouting
From the housetops and the streets
The good news of this great message
To every person that we meet?

Go to Matthew twenty-eight
The last two verses that you see
This is the "Great Commission"
From Christ to you and me

Pay attention to these verses
And let there be no mistake
The Holy Spirit will surely guide you
Each and every step you take

Dependence Day

Again this year on the Fourth of July
We celebrate our independence
Our freedom to practice our faith
Our striving for spiritual transcendence

Now stop and think for a minute
What if we turned things around
Instead of celebrating the usual
Let's celebrate something profound

This year celebrate "Dependence Day"
Dependence on our God
Then celebrate it every day
Hope that doesn't seem too odd

This dependence that we celebrate
Is a celebration of freedom
Freedom from the chains of sin
All glory to the Lamb!

Yes, this Independence Day
I'm thinking of my dependence
On Him who loves me so much
And it's not at all by chance

My dependence on Him was known
Long before the dawn of man
All the details were worked out
In God's wonderful plan

So happy Independence Day
To all my friends out there
May your dependence on Him
Be emphasized with prayer

Draw Me Closer

Father, draw me closer, closer to Thee
This is my wish this is my plea
To the place of the Most High
Draw me close, Lord, draw me nigh

Open up Your righteousness
And Your name I'll gladly bless
I will come and I will praise You
In return my soul You renew

Take my worry in Your hand
While before You I humbly stand
Calm this worried soul of mine
With Your love oh so Divine

May Your Word flow through my soul
Like a river out of control
Filling me up as full as the sea
Filling me up and setting me free

Free to serve You ever nearer
With a purpose ever clearer
Thirsting for a closer walk
With the One Who is the Rock

Draw me closer is what I pray
Closer to You, Lord, every day
Draw me, Lord, quickly please
Draw me, Lord, close to Thee

Forgiveness

After reading about forgiveness
And thinking about it much
The conclusion I have come to
Is it's like a gentle touch

How good it feels to be forgiven
When I have injured you
With a word or with an action
That has made you feel so blue

And when you've wronged me
And I'm the one who's forgiving
That gentle touch I feel
Makes me glad that I am living

To be a better person
And to stay spiritually strong
I must also forgive myself
When I know that I've done wrong

If I'm going to follow Jesus
I can't keep it to myself
It's not a gentle touch
If it's just sitting on the shelf

Lord, thank You for Your example
When they hung You on the tree
For it was Your "gentle touch"
That set my tired soul free

Mountains and Valleys

We all love the mountaintops, I know I do
It's a wonderful experience, that spiritual high
Wouldn't it be wonderful to stay there forever
With nothing in sight but blue sky

Up there we see God in all His beauty
Up there we feel safe and secure
There's a feeling of closeness to Him
Up there our destiny seems sure

Mountaintop experiences have a reason
You must look closely to see it
You may have to look long and hard
And that's not always easy I admit

Mountaintops are there to prepare us
For the time spent down here in the valley
It's not always pleasant and fun
Comparatively, it's like a back alley

God put us back down in this valley
To bring the good news to everyone
To tell the whole world about
Jesus Christ, His one and only Son

When Jesus Himself was baptized
He was high on the mountaintop
But then by the Holy Spirit
Into the wilderness He was dropped

For us will be mountains and valleys
For us will be joy and strife
While we're here on this earth
It is all part of our God-given life

Easter 2011

As Easter approaches again this Spring
We believers with glad hearts sing
Sing songs of joy, sing songs of praise
Anticipation within us raised

We'll celebrate again this year
The risen Savior to us so dear
Who gave for us His life to save
Raised by the Father from the grave

On the cross His blood was shed
Raised on the third day just as He said
So we could commune with God above
Because for us, He has great love

His love for us is why He came
So lift up your hands and praise His name
The One this day we celebrate
While His salvation we all await

And while we wait for His return
This our number one concern
That His life would freely flow
Through our lives so He can show

Show His love for them to see
A love that can truly set them free
Free from worry free from sin
Free for a new life to begin

Easter

Christ crucified for our sins
Counted as one of no worth
Yet He was the only sinless man
E'er tread upon this earth

He left behind a throne in glory
Faithful to the Father's wish
Worked many miracles for mankind
Fed 5 thousand with just 2 fish

Much more than all those miracles
His purpose to achieve
To show a way to the Kingdom
For those who would believe

He was the Passover Lamb
The prophets long ago foretold
His life betrayed by Judas
For 30 pieces of silver 'twas sold

Passover is now called Easter
By us who celebrate this season
Christ rose on the third day
Our salvation was the reason

Spring is a time of renewal
For all of God's creation
So let Christ renew your heart
Everyone in all the nations

Lord, our prayer to You this Easter
Is that our heart You would renew
By the power of Your Holy Spirit
Draw us e'er closer to You

This Year and Next Year

When I think about next year, what do I think?
As this year's almost over, as it continues to shrink
There are many things I have on my mind
What's ahead for me and what I've left behind

I've made some new friends and some have passed
And those that are gone, their memories will last
But I'll see them again and in eternity will spend
With my brothers and sisters, yes, with all my good friends

This year, I've grown in age and in spirit I trust
And my patience has grown and I hope I'm more just
I believe what I've said is to be correct and is true
It's only by Your grace and for that I thank You

I wonder what next year will hold for my life
Will it be filled with joy or maybe with strife?
It matters not what this next year will give
Because it's all in His hands and it's for Him that I live

As long as I remember that He's e're in control
That He has in His hands my future, my soul
Then all will be well this year and the next
Even though this world is confused and complex

So this year and next wherever your journey takes you
No matter where you go or what you go through
Keep your eyes on Jesus, keep your eyes on the Lord
And when He comes for you, you'll receive His reward

True Christmas

'Twas the night before Christmas when high above the earth
All were ready for the Savior's long awaited birth
The shepherds were tending their flocks with great care
And soon would be told that their Savior was here

Joseph and Mary were looking for a bed
For the blessed Lord Jesus to lay His sweet head
But none would be found on that holiest night
While the guiding star shone its bright light

When around the shepherds there arose such a clatter
With great fear they wondered what was the matter
Then the angels of God told them of the good news
In the city of David was born King of the Jews

High in the east the guiding star would show
The curious magi which way they should go
When finally the baby Jesus to them did appear
They were filled with wonder, awe, and great cheer!

Now don't let this story be changed quite so quick
To be told of that stranger who is called St Nick
It seems some have given him a glorious name
And built him up with much fanfare and fame

Remember this year when stringing the lights
And buying all those gifts so shiny and bright
That we worship a Savior who won't share His glory
With some fat little man in that other Christmas story

Jesus Shoes

Our Lord asks that we love
Love each and every person
Especially the poor, the widows
And don't forget the orphan

It's easy to talk about love
It's easy to think about it
But if I'm honest with myself
My guilt I must admit

I'm guilty of letting my love
Sometimes sit and stagnate
Is this the case for you?
Well, you no longer have to wait

Get up and off your keister
Put some feet on your love
Open your heart to Jesus
Hear His voice from up above

You can't do it yourself
It's not just up to you
Stick out your two feet
And put on your Jesus shoes

Just give Him your two feet
And He will do the walking
Just give Him your life
And He will do the talking

Do what He wants us to do
Let Him live His life through us
Open up to the Holy Spirit
And you'll discover true success

God of Wonder

You Lord are marvelous, all my dreams You transcend
You Lord are marvelous, all You do beginning to end

Times I was sure of who You were and how You worked
Now that I am older from those thoughts I have awoke

For Your ways are not mine, neither are Your thoughts
I wonder at Your creation so beautifully wrought

Your wondrous glory displayed in those things before my eyes
And all that is invisible Your wisdom has devised

You are so vast to me and so wonderfully mysterious
And the way You care for me is simply imperious

Thank You, my Lord Jesus, for what You did that day
When he that You loved, Your life did betray

Yet your forgiveness is deeper and wider than the ocean
You give Your love so freely and with such great devotion

I will wonder at this love for now and all eternity
As I thank You and I praise You down on bended knee

Relax

This is the day the Lord has made, rejoice in it

Praise His name all day long, for He has given us a Savior

The Cornerstone of our faith, our Gate to righteousness

Lord hear our gladness, our gratefulness, our joy

This is the day the Lord has made, rest in it

The work has been done, labor no more

Only receive the gift of His love

Bathe in the glory of His love and grace

This is the day the Lord has made, reside in it

This is the only day we will ever have

Live in it and tell of His great works

Plenty of room for joy with no room for fear

This is the day the Lord has made, relax in it

Trust completely in His Word and His Truth

He will accomplish what He has promised

Wait and watch with patience, confidence, and assurance

Today

Today, He was plucked from eternity and dropped here into time
All the glory of God clad in this babe's fragile frame
Proclaimed first to the lowly shepherds
By angelic hosts, His holy name

Bound to the physical laws of space and time
He who knew no bounds
Here to proclaim salvation to all mankind
By His great love for us that abounds

He chose to experience in human form
That which He created so long ago
Like us, starting as a babe
Into a man He would grow

Although fully God and fully man He was
By most misunderstood
But walked as us in human form
Displaying how to live in servant hood

What love He has to leave His throne!
Abandoning all for the sake of the human race
Here for such a very short time
To state to us His case

There is only one way to the Father
This message we can't ignore
Who is this that we behold?
HE IS CHRIST THE LORD!

Always Today

I woke up this morning, it was *today*

When I woke up 10 years ago, it was *today*

If I wake up tomorrow, it will still be *today*

Tomorrow never gets here, it's *always today*

Can't escape *today* with sleep, after the dream, it's still *today*

Upside down forward backward or sideways, it's *always today*

It's the only day we have…ever

Can't fool *today* with a calendar, call it what you will, it's still *today*

You can only "take it one day at a time" because it is *always today*

Guess that's why God says not to worry about tomorrow, *today*

has enough trouble of its own, He only gives grace for *today*

Makes life simple when you look at it that way, because…it's *always today*

Born to Die

We were born with a death sentence, one foot in the grave
Not knowing or caring what it means to behave
Each day that we live is one closer to death
Could the next possibly be my last breath?
A sad state of affairs living day after day
In a fantasy world…It's going to be okay
We think it is, anyway we hope
As we vacantly stare into a kaleidoscope

I looked in a mirror seeing a child
All scruffy haired, angry, and wild
I turned around and saw a man
Wondered what happened to the game plan
Each step I took guided by the unseen
Over and over, the same old routine
Following this, that, or who
Desperately looking for to break through
Born to die, always following the herd
Running headlong into the sword

Is that a train far away in the tunnel
Coming to take me to my final funeral?
I looked at the light, could I be mistaken
Was I in a dream about to awaken?
No, the light I saw was definitely His
Opening eyes, opening ears
Death sentence lifted, life now realized
No longer a zombie, paralyzed
The gift, it's free, it's salvation
Promised e'er since the eve of creation
To all who accept, who earnestly search
For a way to get off that same old perch

Born with a death sentence, now commuted
My life in Him undisputed
Not waiting for death, one foot in the grave
No longer to sin a lifelong slave
No longer looking into the kaleidoscope
Now with Christ Jesus I know love and hope

God Is One

God is the Father
Who reigns over all
From His throne in heaven
His love like a waterfall

God is the Son
All authority given Him
Jesus His name
His love full to the brim

God is the Holy Spirit
Mysterious in form
Filling all who ask
His love like a storm

The Holy Trinity
In the heavens above
Each for each other
Unimaginable love

He's a triune God
Before the beginning of time
Sharing with us
A love so sublime

When They ask you in
To join Their love fest
Don't ignore the invitation
Just bow and say yes!

Your Christmas Miracle

2,000 years ago a miracle took place
Never before or since had it happened
The only virgin birth of a child
As the Son to earth descended

The King of angels Himself came to earth
His thirty-three year journey begun
He humbled Himself to the hand of the Father
In the form of a carpenter's son

From the time of His birth 'til His death
Many miracles did He perform
While preaching His Gospel of life
Many lives did He transform

He looked at us and He said,
"Come all ye weary and heavy laden
Take My yoke and My burden light
Every man and every maiden"

Then in obedience He went to the cross
Made to be sin, He who knew no sin
To transform your stony heart
To a heart of flesh within

Now create your own Christmas miracle
For this special time of year
Give away your love to others
And fill those hearts with cheer

Hope

Lately life has taken a turn for the worse
Steps that went forward are now in reverse
Visions that were clear now appear muddy
Skies that were bright now seem quite cloudy

Illness and death knocking at the door
Sadness and grief ceiling to floor
Can it get worse or will it get better
Will relief be soon or will it be later

Valid questions posed for these days
Is this the new norm or only a phase
What does the future hold for this earth
Is death now better than birth

John sixteen thirty-three says in this life
There will be trouble and there will be strife
Our life will experience great agitation
Distress, suffering, and much tribulation

Yet in the Amplified Version of His Word
He promises our lives are in truth secured
He says be undaunted and filled with great joy
Christ has the victory, enemy destroyed

His conquest accomplished His victory abiding
What He offers us now is most exciting
We can surely survive, with Him we can cope
With eyes on Him, only then have we Hope

You Gave Me Today

Thank You for the gift You gave me today, Lord
I know it's a gift that can't be ignored
You tell me to mold it into whatever I will
To help You've provided me with the skills

I'll start working on it without delay
Thank You for guiding me along the way
The glory is Yours and the honor too
For the gift that was given to me by You

I will return it to You as a love offering
Like a beautiful child that I've been fostering
It's grown and matured into a work of art
Because of the skills You've placed in my heart

I've made mistakes while sculpting this gift
But with Your encouragement I always persist
I need Your help, always have, always will
Working with You, Lord, is truly a thrill

Thank You, Spirit, You're here as my guide
You've always been right here by my side
To help me fashion my rendition
Of this gift bringing it to fruition

Thank You for the gift You gave me today, Lord
I know it's a gift that can't be ignored
It's for Your glory that I obey
To fashion this gift, You Gave Me Today

God's Valentine to Mankind

For God so lo**V**ed the
 world th**A**t He gave
 his on**L**y begotten Son,
that whoso**E**ver
 believeth i**N** him
 should no**T**
 per**I**sh but have
 everlasti**N**g
 lif**E**

About the Author

Gary Blakeman lives in Olathe, Kansas, with his wife, Christy, and his "favorite" mother-in-law, Cathy. He and his wife attend Heartland Community Church in Olathe. He spends his days in his community, volunteering in service to the poor, elderly, and disabled. Sunday mornings, Gary co-facilitates the adult community Bible study at Heartland. He has two beautiful granddaughters.

CPSIA information can be obtained
at www.ICGtesting.com
Printed in the USA
BVHW062212151220
595525BV00001B/2